ART NEEDS
NO JUSTIFICATION

Art Needs No Justification

Hans R. Rookmaaker

REGENT COLLEGE PUBLISHING
Vancouver, British Columbia

First published 1978 by Inter-Varsity Press
38 De Monfort Street, Leicester, LE1 7GP, England

This edition published 2010 by
Regent College Publishing
5800 University Boulevard
Vancouver, BC
V6T 2E4 Canada
Web: www.regentpublishing.com
E-mail: info@regentpublishing.com

Views expressed in works published by
Regent College Publishing are those of the author and
do not necessarily represent the official position
of Regent College.

A cataloguing record for this publication is available from
Library and Archives Canada

Contents

Publisher's preface

Professor Rookmaaker was working on this booklet at the time of his death on March 13th 1977. His intention to write a postscript was never fulfilled.

The material has been re-arranged and revised, but is essentially what the author wrote. In our attempt to be faithful to his intentions we have been greatly helped by his colleague at the Free University of Amsterdam, Drs. Graham Birtwistle.

This booklet is not a technical work, neither are its contents exclusively for the artist. It is for all Christians who are willing to see that their God-given talents can be used to the glory of the Giver. It is not a survey of the art-scene, nor a detailed analysis of the origins of the problems facing civilization. It is a prophetic call to Christian artists, craftsmen and musicians to 'weep, pray, think and work', before it is too late.

Introduction

The artist in our society is in a very peculiar position. On the one hand he is regarded very highly, almost like a high priest of culture who knows the inner secrets of reality. But on the other hand he is a completely superfluous person whom people like to think highly of but are quite ready to allow to starve. We want the artist to be serious and create deep things that have almost an eternal value, things that people of culture can talk about centuries later. But if he wants to be successful he has to bow down to present tastes, be commercial, and play the clown rather than the sage. So he is in the midst of conflicting demands.

Of course this is not a new problem. It has been like this since the 18th century when the old concept of art, the artist as craftsman, began to be exchanged for a concept that saw him at one and the same time as both a gifted genius and a social and economic outcast.

The artist who is a Christian also struggles with these tensions. But the Christian artist's problems are often greater because it is difficult for the Christian to live in a post-Christian world. An artist is expected to work from his own convictions, but these may be seen by his atheistic contemporaries as ultra-conservative if not totally *passé*. On top of this he often lacks the support of his own community, his church and family. To them he seems to be a radical or an idle no-gooder. He is branded as being on the wrong track even from the start. For this reason the Christian artist today is often working under great stress.

On the other hand we very much need art which is healthy and good, and which people can understand. If the Christian can do such work he may not achieve great fame, but many will love his work, and it is possible in this area to make a living. So there is no need for self-pity, and there is a contribution to be made here to an age that is often anti-

Christian in the most outspoken way.

To the many Christian artists that I have had the honour to know, and whose work I think is important in many ways, this little study is dedicated. In fact, this booklet is the working-out of an address delivered at the Arts Festival in 1975 in England, where a few hundred, mostly young, artists gathered who professed to be Christian, or at least were really interested. I must thank Nigel Goodwin and his staff, who organized this and similar conferences, for the invitation, one of the many tokens of friendship based on a common faith and a common interest. It may be clear that I speak in the first place to the painter and sculptor, the creators of the visual arts. I do this because my knowledge lies primarily in that field. But I think that the situation and problems are more or less similar with the other arts; for the musician, composer, actor, writer, dancer, comedian or whatever you may think of.

<div align="right">H.R.R.</div>

1
Background to a dilemma

1:1 Art, craft and the expression of value before the 18th century

There was no sharp distinction between the art of painting and sculpture and what we now call the crafts.

The role of the artist has not always been as it is today. In most cultures, including our own before the new period that began somewhere between 1500 and 1800, the artist was primarily a craftsman: art meant making things according to certain rules, the rules of the trade. The artist was an accomplished worker who knew how to carve a figure, to paint a Madonna, to build a chest, to make a wrought-iron gate, to cast a bronze candlestick, to weave a tapestry, to work in gold or silver, to make a saddle in leather, and so on. As far as organization goes the artist was a member of a guild just like any other skilled worker. Some were master-artists, and took the commissions for the shop. Others were helpers, apprentices, servants. A studio was in fact a workshop with a subtle division of labour under the leadership of the man we now would call the artist, and whose name we sometimes still know.

But even if artists did not have the high honour we tend to grant them today (there were exceptions in the case of artists who were honoured by their patrons), they did make beautiful things; so beautiful, in fact, that we, so many centuries later, still go and look at their works, and often pay much to have their works restored in order to hand them down to the next generation. Their achievements are still considered highly. There is not a tourist-brochure of a city or town or county that does not show with pride the lasting monuments of the past. And whatever those artists themselves gained in the making of those treasures—church-

es, statues, grave-monuments, wall-paintings, reliquaries, lamps, stalls, paintings, illuminated books, houses, stained-glass windows, and so much more—these things today certainly are of great economic value for the tourist trade.

Why are their works still worth looking at? Of course, some are masterpieces, but not all of them. Yet most of them have a reality, a solidity, a human value, that at least testifies to great craftsmanship. They worked in the line of a strong tradition, that handed over patterns and schemes, knowledge of techniques and tools and the handling of them; they were, and felt themselves to be, heirs to the achievements of their predecessors. Not originality, but solid and good work was looked for. Beauty was not an added quality, but the natural result of the appropriate materials and techniques handled with great skill. Their works were not things that asked for intellectual debate and a specialist's interpretation, even if sometimes their works were discussed, praised or criticized. The great St Bernard of Clairvaux, leader of the Cistercian order in the 12th century, took exception to the strange carved creatures, monsters or fantastic animals that were to be found on the capitals in the cloisters; but even if he condemned them, he did take account of them, and criticized their inappropriateness, not their beauty or workmanship.

This art was the expression of a common quality of life, much deeper than affluence and status, and was embedded in a common understanding of life. But within this tradition, this strong framework of skills, of rules and standards, there was freedom. Even if one was asked to copy a certain work one was not supposed to be slavish in execution, but could show one's own hand and qualities. Quality, rather than originality or novelty, was cherished, but the artist could be himself.

Only in this way can we understand the mass of work that is still to be seen throughout Europe. Even if we do not want to romanticize those times, when certainly hard and long work was required, and payment usually limited, all those

old monuments testify to the fact that the work of art was not something to be added later, but formed an integral part of the design of a building. What we call art was the natural beauty that was expected of man-made things. And therefore there was no sharp distinction between the art of painting and sculpture and what we now call the crafts. Skill, quality and appropriateness would be the yardstick.

1:2 The Enlightenment and Art with a capital A

Art now became fine art, and the crafts were set aside as something inferior.

The role of the artist, as well as of the arts themselves, began to change in some European countries in the time of the Renaissance. This movement gained momentum and made a breakthrough in the 18th century, the Age of Reason, the Enlightenment. Art now became fine art, and the crafts were set aside as something inferior. The artist became a genius, a man with very special gifts with which he could give mankind something of almost religious importance in the realm of human achievements, the work of art. Art in a way took the place of religion.

Descartes, in his philosophy, had counted only those things real and important that he understood as rational, clearly and distinctly. But Baumgarten, working from the same Enlightenment basis in the middle of the 18th century, wrote a book called *Aesthetics*, in which he dealt with those things that were not clear and distinct, those that preceded clear knowledge, and were based on feeling, the aesthetic things, the works of art. In this way the breaking of our western world into 'two cultures', the sciences and the arts, became a reality that is still with us. Very much has been written on art in the 18th century, not least in England, on taste, on the beautiful and the sublime, and on the principles of art. We also see the very beginnings of modern art history. Much of this was tied to the world of the connoiss-

13

eur, the man of taste and knowledge, the collector of works of art. Art became disconnected from the normal functions of life, and beauty was seen as an abstract quality, unrelated to what is depicted and carrying its own meaning.

With Kant and, in his wake, Schelling and Hegel, art was considered to be the final solution of the inner contradictions of the philosophical systems designed to form an integrated understanding of reality. Man is free, and yet bound to a mechanistic universe, and it is art which can reveal inner unity and by-pass the rational tensions. Perhaps for this reason music now became the greatest art: it overpowers us emotionally, and yet it cannot easily be analysed. Its content as such is beyond what we can verbalize.

Before this time, no works of 'art' were made, but altar-pieces, portraits, landscapes, paintings or sculptures that were designed to fulfil a specific function, either decorative or to stand as a high metaphor for the greatest values, representations of the Holy Personages, the Virgin and the saints. But now they were to be works of art, and somebody in the middle of the 19th century could write that a still life of a lobster by Chardin could be just as important as a Madonna by Raphael. In fact, subject matter slowly became more and more secondary, leading in our century to the rise of non-figurative art. Photography may have played a part in this, but the trends were there before photography was invented. Art in the 19th century expressed new approaches to reality. It showed that the old norms and values were gone, that the Christian concepts had lost their hold over people's minds.[1]

One more thing is worth thinking about. The 18th century was, if not overtly anti-Christian, certainly searching for an a-Christian world. Religion was fine as long as it was purely private and did not interfere with the important things in this world, science, philosophy, scholarship, the high arts. And so the principle of neutrality was developed: in scholarly work we should leave behind those things that are irrelevant and totally subjective, such as our religious

14

convictions. We should look for the objective; that which is true regardless of our faith. In passing, we just note that the terms used here, subjective and objective, are themselves defined by the Cartesian trends in thinking that were the driving forces in the Age of Reason. These words only have meaning in a framework of thinking where we start from a more or less autonomous and rationalistic man, who sees himself as relating to, and confronted by, an objective nature, ruled by 'eternal laws' like $2 \times 2 = 4$, which has its own kind of autonomy. It is a closed system, to which God or any other non-human or non-natural force has no access; a world where the principle of uniformity reigns and where no other forces than those we know in the world today, those we can see, measure, control, understand, have worked or will ever work. This of course influenced the vision of the artist, but also that of the art historians. So, if today we study the great artists and their achievements, we are never told what was the driving force in their life, what they believed, what they stood for. Those things, being seen as subjective, are left out of the picture. We are given the impression that those great people in the past could make their masterpieces just out of their own genius, talents and insights, and that religion had not much to do with it. We must be aware of this, and not fall for this inherent perversion because it is fundamentally untrue. The modern scholar, historian, art historian or philosopher (as well as the artist), who does more than just follow trends, works from a basic outlook on life and reality. This outlook is often a kind of irreligious religion.

1:3 A crisis in the arts

Art became art for art's sake, a kind of irreligious religion, in a world where religion has no clearly defined practical role.

Out of all this came a crisis in the arts. Art was called to be a kind of religion, a revelation, a mystical solution to the

deepest quests of mankind, but the artist was often hungry and alienated, and unless he bowed down to poor taste and could allow himself to express cheap sentimental content, he was left alone. Art, high Art, was lifted out of daily reality and placed in its own temple, the museum, where the catalogue provides the guide to the liturgy. This has made life very difficult for many artists and art students. Why are they working? What are they working for? For many it has become an individualistic search for their own identity through and in their work. They are like a man looking at himself in the mirror; everything he sees is an expression of himself, and everything else becomes unreal. Art is supposed to be the expression of man's innermost being, but what if you find little inside? The artist is supposed to be a genius, but a genius cannot be taught, we are told, and his delicate subjectivity should not be upset by others who say there is something to learn, so the young artist is left to find and express *himself*. Some reach despair, but they are reminded that it is art itself which will bring deliverance. The poor works of these sad artists often crumble under the load and disintegrate. Basically the artist is being asked to design his own religion which we can talk about, but are never asked to believe completely. Unless the artist is really strong, and endowed with great talents, or filled with a powerful ego-drive, it is hard for him to succeed in the art world.

Art became art for art's sake, a kind of irreligious religion, in a world where religion has no clearly defined practical role. It means that art is such a rarified, special thing that people need art-appreciation courses and lectures to have it all explained. Some indeed must feel as if they are looking at the Emperor's new clothes, in Andersen's tale.

As a result we see people everywhere searching for the meaning of art. The fact that so many books are published that deal with the arts is not a proof that people are sure what art is about, but rather the opposite. This quest for the meaning of art is a sign of the crisis in the arts. But too often this search ends in contradictions. Art has to have a mess-

age, but it should not be didactic; art has to enrich life, but it is only for the rich and specialized. So in a way the really good art, of class and fame, is too far away from the people, and the arts that are popular are seen as below the level of acceptability. Of course, differences in quality and kind have always existed, but the sharp division of today is a new phenomenon.

I see this as the result of placing art on too high a pedestal, lifting it out of its ties with daily realities to the level of museum-art, the work of a genius. Art has suffered from this. High Art has shunned all practical demands, such as decoration, entertainment or in fact any role that might smack of involvement in real life. Yet this type of art inevitably attracts almost everybody who has some talent. So in the art colleges there are many who study painting or sculpture as a free vocation and they will become the 'free' artists of tomorrow, most of whom will not be able to live from their work.

But inevitably the 'low' arts have suffered also. They became the 'popular' arts, sometimes called 'commercial'. It is art in the service of Mammon. As all genuinely talented people tend to shun this field, its quality has deteriorated, and too often what is produced lacks all imagination or quality. And because that is usually the art that is offered for 'consumption', it means that everybody, knowingly or not, suffers. It has its share in the ugliness of our world today.

Now, at the beginning of the last quarter of the 20th century, it is good to balance the books and ask what we are doing, and how far we have come. A friend of mine said to me some time ago, 'When you published your book on the death of a culture[2] I thought you were much too pessimistic. Today, as I look around in the field of the arts, high, low and in whatever medium, I think you are right.'

There are always exceptions, for example in the graphic arts and industrial design, even if here not much really exciting and new is to be found. But if these fields are better, it is certainly the result of the work of many concerned

17

people. Laments over the low quality of the arts that were produced, especially in the field of the crafts, the aesthetic design of things for daily use, had already begun in the last century. I can cite the names of Ruskin, Morris and his Arts and Crafts movement, and there are many more.[3] In our century we cannot by-pass the Bauhaus, which had a healthy influence on design in general. But looking at all those efforts we cannot say that the goals set more than a century ago were achieved.

Maybe it was one-sided to look mainly at the design arts as needing renewal and strengthening. Perhaps there ought to have been more discussion about the pretentiousness of high Art. But certainly those who were involved were usually concerned for the good of society and not only for aesthetics and artistic quality.

1:4 A crisis in our culture.

The quality of our lives is tainted, and words such as alienation, despair, loneliness, in short dehumanization, *are all relevant and have to be used too often.*

Most of the activists, critics and artists, who tried to renew the arts and give our world a more beautiful face, did argue in one way or another that just to face problems in art was not enough. They understood, with more or less clarity, that the crisis in the arts relates to a very deep crisis in our whole culture, and that the crisis in the arts is an expression of this much greater crisis. That greater crisis is of a spiritual nature, and, as such, affects all aspects of society including economics, technology and morality. The quality of our lives is tainted, and words such as alienation, despair, loneliness, in short *dehumanization*, are all relevant and have to be used too often.

This is not the place to go into an analysis of all these things. Certainly the problems are related to the fact that, since the Age of Reason, we have only looked at the relation-

18

ship of man with nature, in order to master reality and use it to our advantage. But as C. S. Lewis in *The Abolition of Man* has analysed so ironically, to master nature, and to be able to use its powers, is usually only the privilege of the few. The few are therefore better able to exert power over the many, the masses. Manipulation and loss of real power to live the life one wants to live are the result. Counter-efforts are made everywhere to change things or to try to overcome the evils of the system, and the Marxists are conspicuous in this. Many listen to them since they at least signal the evils. But whether their remedy is not worse than the illness is a real question. If alienation only means that our relationship to things is broken; if the overpowering of nature is still seen as a goal; if material values are still the primal aim, and if the problem of sin is avoided, the most serious questions remain.

Yet, if we work for a better society and for a resolution of the crisis in the arts, changes will have to come. It is good to think these problems through and we must not expect solutions just to arrive on our doorstep. Much time will be involved. But we should be on the move, all of us, including the artist.

1 I refer the reader to the excellent book by Linda Nochlin on the *Realism of the 19th century*, or the exciting lectures of Barzun under the title *The use and abuse of art* (Princeton University Press, 1973).

2 H. R. Rookmaaker, *Modern art and the death of a culture* (IVP, 1970).

3 See Pevsner's book *Pioneers of Modern Design* (Penguin, 1960).

2
The church's response

2:1 The Christian retreat from the world

In concentrating on saving souls [Christians] have often forgotten that God is the God of life.

If, as we have said, in the 18th century our world began to change, as its inner direction was set on a humanistic track, where man is the master, and pleasure (through money) and power are the ultimate values, where were the Christians? They were not few in number, and some people even call that same period one of great revival. The mainstream of Christianity turned to a kind of pietism in which the idea of the covenant, as preached in the books of Moses and throughout the whole of Scripture, was by-passed. The Old Testament was often neglected, and the meaning of the Christian life was narrowed to that of the devotional life alone. Too easily, large areas of human reality, such as philosophy, science, the arts, economics and politics were handed over to the 'world', as Christians concentrated mainly on pious activities. If the world's system was a secularized one, missing true spirituality, the Christian's attitude also became a reduced one, missing its foundation in reality and uninterested in the created world. It became sometimes a ghost-like spirituality without a body. Christians have indeed been active. But they have often optimistically believed that it was enough to preach the gospel, and to help in a charitable way. In concentrating on saving souls they have often forgotten that God is the God of life, and that the Bible teaches people how to live, how to deal with our world, God's creation. The result is that even if many became Christians, nevertheless our present world is a totally secularized one, in which Christianity has almost no influence. Our society's drive is determined by the world and its values, or lack of values.

2:2 Two consequences

a. Christian standards in art are lowered

Just as a man shows who he is by his clothes and the way he moves, so these things, music, posters, in one word, art, are the things that form our first, and sometimes decisive, communication.

If we say that to work as an artist is not spiritual enough and that art has no place in the Christian life, we are open to deep conflicts and contradictions. I know of a Bible school where they had organized a course on 'Christianity and culture'. Question one was: What has Christianity to do with culture? As they were not able to answer this, the next question was: Why do we have this course? But, what happens when these students leave the school and begin their work, let's say in evangelism, and start a campaign somewhere? There may be a big tent and a fine preacher. But what about the music that will be played before this man speaks? Or will there be no music? And if there is music, what kind of music will it be? Should we not think about that? Or doesn't that matter? Music is also communication. Suppose this communication 'spoke' the opposite to what the fine speaker said? The same applies to the pamphlets we are handing out, the posters we are making. These should be well designed and in good taste; they are often the outsider's first encounter with Christians and in a way they constitute our outward face and appearance. Just as a man shows who he is by his clothes and the way he moves, so these things, music, posters, in one word, art, are the things that form our first, and sometimes decisive, communication.

And if we have responsibility for the building of a church, should it just be bare? St Bernard of Clairvaux, the great leader of the Cistercian order in the 12th century, wanted the monastic churches bare and simple; but the architecture was beautiful. People still go to these old monastery churches to look at the fine architecture. But if we do not go that far, and look for some appropriate decoration, a

stained-glass window for instance, should we not look for a good artist? And who is going to play the organ? And what does he play? Very often we have created barriers against the hearing of the gospel because we preached that we care for people and that this world is God's own, but we did not act on that principle. Our lack of care showed that we were not really interested in people and in God's creation.

From the Middle Ages through the time of the Reformation, up to around 1800, when spiritualistic pietism began to drive beauty out of the church (as if one can have inward beauty without the outward signs of it), there may have been simplicity, but always beauty, in the things the Christians did. That was not a programme, it was just the natural way of doing things; art had not yet become Art. In fact, these things were so beautiful and good that people still go and look at them. The paintings of Rembrandt (from *Christ on the road to Emmaus* to a still life), the fine churches, the crucifix, the music of Bach (church cantatas as well as the *Brandenburg concertos*), the poems of John Donne, Handel's *Messiah*, and also his *Water Music*, indeed too much to be enumerated, all still testify in this secularized age that Christianity at least once did mean something. And these things sometimes still communicate their message. Quite without realizing it, these people, the patrons, the artist and the Christians in those days, erected signs for another age that the Lord had done great things in the world. Today they are often the only witness of a Christian mentality in our public life. For that reason it is good that Christians work as art historians and museum staff, keeping alive the understanding of these old things, which point to the eternal Word of God.

b. Christians fail to come to terms with culture

In Christian circles a negative attitude can still be found towards culture (in a narrow sense) and the arts.

This is not the place to discuss all facets of the Christian

23

faith. But we ought to realize that, in Christian circles, a negative attitude can still be found towards culture (in a narrow sense) and the arts.

We should remind ourselves that Christ did not come to make us Christians, or to save our souls only, but that he came to redeem us in order that we might be human, in the full sense of that word. To be new people means that we can begin to act in our full, free, human capacity, in all facets of our lives. Therefore to be a Christian means that one has humanity, the freedom to work in God's creation and to use the talents God has given to each of us, to his glory and to the benefit of our neighbours. So, if we have artistic talents, they should be used.

And the Lord knows why he is giving these. Paul in his letter to the Corinthians (1 Cor. 12:12 ff.) speaks about the Christian community as the body of Christ. Each has his specific function therein. And not one can be missed out. Certainly some are those who play the music, draw the likenesses, photograph the movements, write the stories, and these are the artists. They have their rightful place in the family of God and cannot be left out. Again, the life of the body of Christ, and certainly a renewal, an awakening, is impossible without these members, called by God to do their job.

As the body moves, works, thinks, speaks, not for its own sake, but called by God to be 'the salt of the earth', the artists are not just servants of a Christian sub-culture, but are called to work for the benefit of all. Of course, at times it may be unavoidable that we work for the sub-culture, or that we *are* a sub-culture. Sometimes we have to withdraw if the world asks us to do things we cannot do for his sake, that are negative and destructive. But if we are rejected, not for being foolish, or stubborn, or trying to bully everybody into our own ways and customs, but because we don't want to compromise our real biblical principles, we can expect the Lord to help us. Remember that he said to his disciples that if you have forsaken these very important and basic things,

24

near to our heart and in the centre of our life, for his sake, he will give back in another way, in this life and he will take care of us (Mark 10:28 ff.). But although we must not forsake his ways, we are not only free but called to work for the benefit of all the people around us.

2:3 A call for reformation

I am convinced that only a real reformation can lead to a renewal of our culture, a reformation not only of Christianity, even if it certainly has to begin there, but of our western world.

If Christians often feel so much at home in this world, then we have to ask ourselves whether we have not been influenced by the standards of the world around us. Maybe the realm of our faith is a tiny part of our life, where piety and devotional literature still have a place. But our life-style, the music we listen to, the values we endorse in practice, are they different from those of society around us? No wonder that, to many, the weekly short sermon, listened to in our easy chairs, becomes other-worldly and unpractical, religious in a narrow sense, more a question of feeling than daily reality. We sing that Jesus is the answer; yes, but to what?

Deep inside I am convinced that only a real reformation can lead to a renewal of our culture, a reformation not only of Christianity, even if it certainly has to begin there, but of our western world. I do not believe in the Marxist solution or a technological solution.

Christians need to wake up, and their feeling of power-lessness or futility has to be replaced by a new impetus to work. In short, Christians themselves need to be aware of the fact that the only prophetic word for today is 'turn back to the Lord' and look to him for solutions. Let us listen again to his word. The Old Testament prophets spoke to a world that had known the word of the Lord and had turned away, to live what we now would call a secularized life,

light-heartedly by-passing the many ills of their day. These prophets did not speak of a sweet, saving grace disconnected from a turning away from the evils of their days and a return to his commandments. The reading of the prophets is not easy these days, and their words are alarmingly relevant for our times.

Of course, nothing can be done if the Lord does not go before us. We cannot make a new spirit or turn judgment and curse into blessings. The Lord has to move. Our prayer is as those fellow-believers of old who composed and sang songs like Psalm 10, 'Why dost thou stand afar off, O Lord? Why dost thou hide thyself in times of trouble?' We are admonished in Zephaniah (2:3), in a situation very much like our own, 'Seek the Lord, all you humble of the land, who do his commands; seek righteousness, seek humility . . .' and although there is no promise that Christianity will again be acknowledged as influential in our society, our task is not to shy away from our responsibilities. We are called to be the salt of the earth, working against corruption. We are admonished to be humble, not to dream of doing God's work in our own strength, but at the same time we are commanded to *be* righteous, to *do* our task, to *walk* in God's ways, and that means to care for this reality that is his creation. We have a task, if we love the Lord and therefore want his name to be hallowed, his Kingdom to come. Everybody, each in his own place, must begin at this beginning. The artist is not excluded. In fact, I think he has an important part to play.

2:4 Weep, pray, think and work

The 'beginning' I refer to can be summed up in this formula, weep, pray, think, work.

This is what the prophet meant in his day when he wrote, 'As for me, I will look to the Lord' with the great expectation that follows (Mi. 7:7-11).

Weep for the present situation. See how far we have

drifted from an acceptable foundation. Let us care about the many who lead lives that seem to be empty and useless. Even the world is concerned about these things. TV shows that commercialism, violence, sex, cheap entertainment and escapism in a totally secularized world are the only realities left. Meaning has to be rediscovered and restored to our actions and endeavours. We must analyse the situation and try to find out what is wrong, and to assess our own place and role in it.

To weep is to see that things must change; to begin to care for the victims, and to pray for forgiveness. Too often we have been accomplices in all that has happened. Would the Lord not speak to us as in the days of Amos (indeed, these things were written down in order that we should learn from them), 'Woe to those who lie upon beds of ivory . . . who sing idle songs to the sound of the harp . . . who drink wine in bowls and anoint themselves with the finest oils, but are not grieved over the ruin of Joseph!' (Amos 6:4 ff.)? The question is how far our affluence today can be considered a blessing, and how far it is a blessing turned into a curse. Can we stand easily before the Lord with all our commodities, the things invented to make life easy and luxurious? To weep is also to see our own weakness, our own shortcomings, and to see where our love and our care and our efforts have been lacking. It drives us on to prayer.

We pray in the knowledge that we cannot change things ourselves and that we need help. We pray also to ask for wisdom, strength and perseverance to work for a better solution. Perseverance certainly is the most difficult, to know that it will all take time, that it is not enough to work now, but that we must go on, and that perhaps we may never see the results ourselves.

The great Reformation of Luther and Calvin was in the early 16th century, and the rest of that century saw a situation of confusion in the search for new principles and methods. But out of all the work done, in obedience to the

Lord, listening again to his word, grew another culture, in many ways better and richer in spirit. The arts of the first half of the 17th century were in many ways fruits of this; not perfect, but rich. The world's museums are still full of the works of those times. To change a whole society, to re-organize thought-forms, customs and insights, takes much time and the changes were only very partially realized.[1] But interestingly, the arts were part of it all, and did not tag on behind.

When we have asked the Lord for help and listened to his words, we must think, think out our position, where to begin and how. I'm convinced that we will never really get out of the problems, the crisis, unless we see how we have been caught by the spirit of the Enlightenment, believing in the power of Reason and relegating any belief in God to the subjective and strictly personal. God is good in saving souls, but we have tended to keep him away from our big decisions in scholarship, science, politics and so on. We have got to understand the thought-forms of western intellectual history and their consequences; a reduced world, relativism, neutralism, neutrality of values which are a-Christian if not anti-Christian. We have to think through the proposed solutions, including Marxism, and so prepare ourselves. This thinking is the task not only of the great philosophers. We are all involved, even if we have different tasks.

We must also think through what Christianity means, and its relation to cultural issues. We have been freewheeling too long on this point, taking the words of the few people who dealt with this as sufficient. Indeed, our Christianity itself must be thought through again. There is no reformation without theological renewal, or rather, a strengthening of biblical insights.

And only then we can come to action and do something with perseverance. Of course, then we can start again; the

sequence has its own logic; the one cannot be begun unless the other has been done.

Weep, pray, think and work.

1 I should like to recommend Charles Webster's *The great instauration* (Duckworth, London 1975) in which he tells at least part of that story.

3
The Christian artist's task

3:1 The role of the artist in reformation

We are looking for the artist who is working within *society and in that way is taking his share in making life livable, rich in a spiritual sense, deep and exciting.*

The artist cannot wait, in fact nobody can, till the world is renewed, the crisis solved, and new cultural principles worked out. We have to participate in the life of our times. In fact the artist stands maybe in the most difficult place, as the spirit of anti-Christianity, of dehumanization, of despair is strongest in the avant-garde tradition of the arts. But maybe there is still something left of the strong old traditions that can be used as a starting point. But it must be tions that can be used as a starting point. But it must be given a new foundation, so that it can be a living reality, not just a tradition.

But the artist is in a crucial place. He has to take part in this movement, a movement that has no organization, that has no name, the movement that I call reformation, the return to the Lord, to seek the Truth, the Way and the Life that is in Christ Jesus. The artist must be part of it. The arts are in principle very concerned to protest against technocracy and look for alternatives.

The artist is the one to create the poems, the songs, the images, the metaphors, the forms that can both express what has been gained in insight, wisdom and direction, and pass them on to others in a positive and incisive way.

Often the question has been posed whether there is a place for art in the Christian framework. Do we need art? is the question. And the answer is, it depends what you are talking about. If one means whether a certain percentage of the art produced for the museum should be by Christians, then certainly one can say that it has a place as it makes the presence of Christians felt; but that is not the main thing that

we are looking for. We are looking for the artist who is working *within* society and in that way is taking his share in making life livable, rich in a spiritual sense, deep and exciting.

We should not think that this is something light or easy. To do this work is difficult. One has to make sacrifices, do things that others think irrelevant. Economically it probably means being in a weak or vulnerable position. A common sense art theory, that may be a guideline for the artist without being a legalistic set of rules, but enhancing his freedom, is very much needed. But as there is little help coming from the leaders of the church, the Christian intellectuals, every artist as it were has to work it out himself. Indeed, if we are not assuming our responsibility on all levels of human life, we leave the artist too much on his own.

So if we want to give the artist a share in the totality of the Christian life (weeping, praying, thinking, working); if we understand that without the artists and their work a reformation is not only unlikely but unfeasible, then we have to think about these responsibilities. It will mean that we have to think through our Christian position and what Christianity means.

The reformation I have been talking about is not only a church reformation. The totality of our being is at stake. It certainly is not only in evangelism or church work, even if those things are important and should be done too. But to preach the gospel, and to say that in Christ there is life, without being able to show something of the reality of that life, is to speak in a vacuum. It soon begins to sound false.

The difference must be visible, in all fields. As C. S. Lewis says so beautifully, we have enough little Christian tracts and books, but if we look for the re-Christianization of Europe or the US it will not come if people cannot look for a good book in a certain field and find that the book comes out of the Christian camp. The world did not become atheist because 'they' preached so hard, but because they worked so hard, and in many fields 'they' have led the way, set the tone. Art certainly has a great influence on people. Just think of

32

the role of rock music in the sixties. If there were creative, exciting and good Christian music around, if there were visual art that was truly different, not strange but good, if . . . then Christianity would have more to say. It would have more to say to the world outside the west, the so-called third world.

Often we are satisfied too soon, too easily. We pick up what the world does, change some obvious things, and then we think we have arrived. Our paintings are sometimes the same as 'theirs', maybe just a little bit less shocking or radical. But to be a Christian is not to be conservative, or less exciting. Of course, the artist cannot do it alone. He needs the writers of those books, the thinkers who think new thoughts, the politicians who offer other solutions, and also the preachers and pastors to help us to see the way and walk the way.

Only in such a community can we move on. But if others fail, or are weak for whatever reason, we must just go ahead and show what can be done. Maybe what you artists do is also weak and feeble. But let us not wait. Maybe the reformation we look for will never come if we do not weep, pray, think and work.

But I think all we have been saying is obvious. And therefore the artist needs no justification. God called him, gave him talents. We cannot go without him. So let's help him; in prayer, in encouragement, not just with words, but also in deeds according to what we can give. Indeed, what we cannot afford to be without needs no justification.

3:2 How the Christian artist works

What we do will be for the benefit of our fellow men, but our future, our salvation, lie in Christ Jesus even if we have failed, and therefore there can be peace and openness . . . work out of the fullness of your being; give the best you have.

People say to the artist (and this is done all too often), 'to

33

be an artist is fine, if your art can be used for evangelism.'
And so art has often become a tool for evangelism. Now let's
be precise. As such there is nothing against this. But we must
be aware that art cannot be used to show the validity of
Christianity; it should rather be the reverse. Christianity is
true; things and actions and human endeavour only get
their meaning from their relationship to God, and if Christ
came to make us human, the humanity and the reality of art
find their foundation in him. So art should not be used to
preach even if it can help. But this is not the only way that
art can be or is meaningful. All too often artists, in order to
fit into the patterns of evangelism, have compromised, and
so prostituted their art. Handel with his *Messiah*, Bach with
his *Matthew Passion*, Rembrandt with his *Denial of St Peter*,
and the architects of those Cistercian churches were not
evangelizing, nor making tools for evangelism; they worked
to the glory of God. They did not compromise their art.
They were not devising tools for religious propaganda or
holy advertisement. And precisely because of that they were
deep and important. Their works were not the means to an
end, the winning of souls, but they were meaningful and an
end in themselves, to God's glory, and showing forth some-
thing of the love that makes things warm and real. Art has
too often become insincere and second-rate in its very effort
to speak to all people, and to communicate a message that
art was not meant to communicate. In short, art has its own
validity and meaning, certainly in the Christian framework.
About that we want to speak later.

The Christian's art must be Christian in a deep sense,
showing the fruits of the Spirit in a positive mentality, and
excitement for the greatness of the life we were given, but
that does not mean the subjects have to be 'Christian' in a
narrow way. The *Brandenburg concertos* by Bach are no less
Christian than his *Passion,* nor Rembrandt's *Jewish Bride*
than his biblical subjects. Indeed, to ask the artist to be an
evangelist points to a total misunderstanding of the meaning
of art, and, for that matter, of other human activities. We

34

are Christians whether we sleep, eat, work very concentratedly on solving a problem; whatever we are doing, we do it as God's children. Our Christianity is not only for the pious moments, our religious acts. Nor is the aim of life evangelism; it is seeking the Kingdom of God.

So, to put it into a metaphor; art should not be compared with preaching. The best work of art would still be bad preaching. It may be compared with teaching, but the teacher often has to speak of mathematics, geography, history, botany, and sometimes, even if rarely, about religion. But the best comparison is maybe with the plumber. Just as plumbing is totally indispensable in our homes, yet we are rarely aware of it, so art fulfils an important function in our lives, in creating the atmosphere in which we live, in giving us the words to speak, in offering us the framework in which we can see and grasp things, say a landscape, even without our noticing it. Art is rarely propaganda, but it has been very influential in shaping the thought-forms of our times, the values people cherish. So the mentality that speaks out in art is important. Its greatest influence is maybe right there where it is most like plumbing, and we are not aware of it.

I think that we should not say that there is something 'behind' our actions, but that the deep strivings, the love and the hate, the wisdom and the foolishness, the knowledge and the insight as well as the shortsightedness and false idealism, all this and much more are not 'behind' the action but 'in' it. Therefore, to work as a Christian is not doing the thing plus something added, the Christian element. A Christian painting, if we use that term with any intrinsic, serious meaning, should not be just a painting plus an added something. Nor should it be holy in a special sense. Art has its own justification.

But because a painting is a human creation, and as such is the realization of human imagination, it is 'spiritual', that is, shows what is inside man. These things are communicated,

for art is also communication. And everything human attests to the human, and the human is never just something neutral, a void. The painting is loaded with meaning. The better it is the more this will be true. When we understand anything of art, we know that techniques, materials, size, all these technical elements, are chosen to be a suitable tool for expressing what one wants to do. So the spiritual and the material are necessarily closely interconnected. And therefore the saying that after all a painting is just a painting will not do. This is often said to stress the fact that our particular spirituality has nothing to do with it, which implies that one has nothing to say, and that there is no humanity expressed, living itself out in the work.

So we are struggling to express clearly what the Christian element in the work of a Christian is, what the Bible calls 'fruit of the Spirit' (Gal. 5:22). What has to be stressed is that it ought to be human, real. The Christian element never comes as an extra. In discussions I am often asked what one has to do if one wants to work as a Christian. I have the feeling that often these questions are within a legalistic framework, as if the Christian element consisted of the following of some rules, usually of a negative kind. May I do this? Can that be done? But in that way we understand our own spirituality too mechanically. We are not human plus an extra called our Christianity. No, our humanity reacts to the world outside and the Word of God, in a way that is specific to our particular personality.

To be a Christian artist means that one's particular calling is to use one's talents to the glory of God, as an act of love towards God, and as a loving service to our fellowmen. It means to be on the way, preparing ourselves as well as we can, learning 'the trade', techniques and principles, learning from the work of others, and from their mistakes, finding our direction, experimenting, achieving what we set out to do, or failing. To work in such a way, with all our heart and mind and spirit, with all our potential talents, in openness and freedom, praying for wisdom and guidance, thinking

before we work, is to accept our responsibility. Self-criticism is needed, of course, but to be a Christian artist does not mean to be perfect, nor to make things without faults. Christians are sometimes foolish, sometimes make mistakes, maybe out of their sinfulness, but maybe because the task was too difficult, or because we got wrong advice, certainly because we are human, living in a broken world under the curse. To be a Christian does not mean that one is a genius.

If you are a Christian, don't be ashamed of it. Work out of the fullness of your being and give the best you have. You can never be better than you are. Be ashamed to be less, but you fall into pride and foolishness if you want to be more. This means don't be afraid, and live out your freedom. And don't let this be spoiled by your sinfulness. Sin takes freedom away. Walk in his way, yes, but this must be done out of your own convictions, out of your own understanding, and in love and freedom. It is never just the application of some rules, some do's and some don'ts. It is more real, more honest. It should be a commitment.

So we must work in the best way we can and if we do so we are already participating and changing things. To be a Christian is to be different. Not totally; nobody can be totally different. If we were, we would be total strangers, speaking a foreign tongue, and we could not communicate any more. Also it is impossible to think through everything, so, in many ways, we will be children of our age. Unavoidably we will have much in common with all our contemporaries. We eat the same food, use the same clothes, go to the same stores, speak the same language, read the same papers, have had the same schooling, have gone through the same experiences, droughts, inflation, ups and downs, war and peace. Yet, we are different.

There are things we hate and they love, even knowing that they lead to death, as Paul says at the end of Romans 1. There are also things we do, love, look for, work for,

because we find them to be part of going 'on the way', hungering and thirsting for righteousness, looking for that which is positive.

The Christian is different; he partakes of the framework of his time, and also adds to it. Maybe his total framework is larger and richer because of this. We trust it will be. And let us realize that the differences count. Not to do the obvious, or to do something nobody else does, that difference counts. And we never do that alone. We learn from our friends, and we teach them things too. We work together. And our group, our fellow-travellers on the way, his way, are again part of a larger group, and that finally is part of the totality of his people, God's holy church in the wide sense, the communion of saints. And so we, by criticizing or protesting, and by showing the better way can maybe influence people. It may be the beginning of something God may use in a reformation; but that is his part. Our responsibility is to be good servants, and to do what our hands are given to do.

So we should not lose hope as long as we do our share. Later, maybe only after the last day, we shall see that it did make a difference. Read Malachi 3:16, 18.

4
Some guidelines for the artist

4:1 Art needs no justification

*Art has . . . its own meaning as God's creation; it does not
need justification. Its justification is its being a God-given
possibility.*

In the beginning we stated that art became Art in the 18th
century and that the consequences of this have been
disastrous to art. Yet there is some truth in the idea that art
has a place of its own. We cannot try to 'justify' art, saying
that it fulfils this or that function. This has been tried in
many ways. But even if art sometimes fulfils one or another
function, that cannot be its deepest meaning. When times
change and old functions become obsolete, we put art works
in the museum; they have lost their function but they are
still works of art and, as such, meaningful.

To explain what I think is the right approach, I should like
to focus for a moment on a tree. A tree has many functions;
it has beauty; it can cast a shadow; in its branches the birds
can build their nests; it produces oxygen; when it is dead it
can be used as wood, and much more. Yet the meaning of
the tree, its existence and reality as a creature, is not in these
functions or not even in the sum total of these functions, but
exactly in its being a creature, owing its existence to the
great God Almighty who is the Creator. The tree has its own
meaning, given by God. It is no less a tree when some of its
functions for one reason or another are not realized. Rather,
being meaningful, it has many functions.

The same is true of human beings. They are meaningful
for who they are, not for what they have. Their meaning is
not in the possessions they have, nor in their qualities or
talents. The fine preacher, who has such a talent for speak-
ing, does not lose his humanity nor his meaning in the sight
of God and his fellow men if he falls ill and therefore

cannot speak. The meaning is in what one is, not what one has.

The same is true of art. God gave humanity the skill to make things beautiful, to make music, to write poems, to make sculpture, to decorate things. The artistic possibilities are there to be actualized, realized by man, and to be given a concrete form. God gave this to mankind and its meaning is exactly in its givenness. It is given by God, has to be done through God, that is through the talents he gives, in obedience to him and in love for him and our fellow men, and in this way offered to him.

But if art has in this way its own meaning as God's creation it does not need justification. Its justification is its being a God-given possibility. Nevertheless it can fulfil many functions, and this is a proof of the richness and unity of God's creation. It can be used for communication, to stand for high values, to decorate our environment, or just to be a thing of beauty. It can be used in the church. We make a fine baptismal font; we use good silverware for our communion service, and so on. But its use is much wider than that. Its uses are manifold. Yet, all these possibilities together do not 'justify' art. Art has its own meaning. A work of art can stand in the art gallery and just be cherished for its own sake. We listen to a piece of music just to enjoy it, a kind of enjoyment that is not merely hedonistic; it surpasses that, even if in some cases it can give great pleasure. But it has the possibility of a great number of functions, that are the result of the fact that art is tied with a thousand ties to reality. It is exactly this last element that has been underrated by those people who spoke of high Art as autonomous, for its own sake.

As art does not need justification, nobody has to be excused for making art. The artist does not need justification, just as a butcher, a gardener, a taxi driver, a policeman or a nurse do not need to justify with clever arguments why they are doing their work. The meaning of their work and life is certainly not in giving an opportunity to preach or to witness.

A plumber who gives some great evangelistic talk, but lets the water leak on, is not doing his job. He is a bad plumber. It becomes clear that he does not love his neighbour. The meaning of these jobs is in the love for God and the neighbour, and each person prays, in his own way, 'Thy Kingdom come, Hallowed be thy name', and works towards that in his specific job. We minimize this, and in a way destroy our understanding of what God called us to do, if we speak about 'playing a role', or fulfilling a function. There is more to it. It is the same for the artist. He needs no justification; not in the sense we are using the term here. Of course he needs justification as much as anyone else, if we use the term in its theological sense. The artist is a human being, and, as such, sinful and in need of the justification through the finished work of Christ on the Cross. The Christian works as a 'new being' in the sense of Romans 6 and his art work is as much part of his Christian being as all the other human activities we mentioned; just as much as that of the preacher or evangelist.

If we see a good work of art it is not out of place to pray 'thank you Lord'. It is a gift of God. Maybe we are thanking God because he answered the prayer of the artist who asked God's help and guidance. And certainly there would be no good art if Christ had not come to lift the curse from this world, and save it from becoming hell itself. Art itself is a potential given by God. We, humanity, only discover this, and use it in a better or poorer way. This truth makes it also impossible to make a kind of religion out of art, as is often the case with modern art. God certainly does not want us to turn art into a god, making beauty our highest aim. Aestheticism means giving art a place it does not deserve, and it can be very destructive.

This does not mean that art can never have a place in religious worship. Indeed, the making of idols is forbidden; but just as we take good care in preparing a gift for somebody we love or think highly of (the love we have is shown, expressed, in the choice as well as in the packaging), we do

our best to make our songs as good as we can, make our building as beautiful as we can. Beauty can be very simple. Taste cannot be bought with money, though money is sometimes rightfully spent on it.

4:2 Art and reality

This is reality: the potential world outside as far as we know it, in the way we know it. The interesting thing is that the painter paints what he sees, but as he sees what he knows, we can also say that he paints what he knows.

'Art consists of two facets, two qualities, communication and form. The communication is always through the form, and the form always communicates values and meanings.

It can depict reality outside of man, as understood and seen by man. That reality can be the things we can see, but also the things we experience, realities like love, faith, care, righteousness, and their negative, evil counterparts.

Reality is outside us, again as a potential to be discovered and to be realized. For example; America was there before any European came there. Yet in a way it wasn't there for the people in the European world. It had to be discovered, and when that took place its possibilities had to be realized, opened up, made available. If we now look at that same America, after so many centuries, we see what western man has made of it. He has opened it up, made bridges, roads cities and parks. He has realized its potential to bear fruits, and made a livable place out of it. But he also destroyed much. So we see that there are many wounds in the reality of that land and its inhabitants, human and animal and botanic. So the America that is there now is a realized reality, showing what man made out of it. The quality of that is what counts.

So reality is not simply (objectively) there. Reality is potentiality. The reality that we know is always a realized reality. We discovered it, named it, made it accessible. So we

can make the statement that we always see what we know, or understand, of the world outside. This is reality; the potential world outside as far as we know it, in the way we know it. The interesting thing is that the painter paints what he sees, but as he sees what he knows, we can also say that he paints what he knows. In the painting, in his visual communication, we can see what the artist, as a member of the human race, standing at a certain point of its history, knew and understood of reality. But man's vision of reality is not just knowledge, in the sense of knowing what is there, but creation, in the sense that he wants to realize his vision in the same reality. The quality of that vision counts. It may be building up and opening up, positive, good, beautiful; or it may be negative, destructive, ugly, poor. Usually it is a mixture of these two extremes.

Reality is the present; it also encompasses the past. It is the things seen, and the things not seen but nevertheless very real, like love, hate, justice, beauty, goodness and evil. So if a painter paints something he will always choose what he thinks is relevant, important for him or for us. If he paints the past he will do so because he judges that past to be meaningful for us now. And in doing so he will show his understanding of it. So if an artist depicts the Christmas story, he does so not only because it happened so many years ago, but because he understands that to be still of great value and importance to us. And he will show what his understanding of it is. Therefore, if we see the many cheap and sentimental Christmas cards we really have to question what they stand for. Should that be the understanding of that story now? Isn't that too cheap, unworthy of the reality of the Son of God coming into this world? Is that the quality of our Christianity? If it is, and I think it is, it raises many questions!

In this way I am trying to make clear that art is not neutral. We can and ought to judge its content, its meaning, the quality of understanding of reality that is embodied in it.

Undoubtedly, there is also a second approach to quality,

the way the work is done, the kind of colours used, the beauty of the lines, in short the artistic quality. Theoretically these two ways of judging art can be separated, but in actuality they usually fall together, because we only know the vision and understanding through the embodiment in the composition and artistic realization of the work of art. As art is tied to reality in this way, there is a place to speak about truth in art; does it do justice to what it represents? Does it do this in a positive way? Does it show the depth and complexity of what it is talking about? Art may be simple; it must be clear, but never silly or shallow.

4:3 Art and society

Art helps us to give form to facets of our life and helps us to grasp reality.

Art has a complex place in society. It creates the significant images by which those things that are important and common in a society are expressed. By the artistic image the essence of a society is made common property and reality. It gives these things a form, not just in an intellectual way, but so that they can be taken emotionally, in a very full sense. Emotional does not mean anti-intellectual, but more than intellectual. We think about flags, landscapes, portraits, the songs sung about the land we love; and so much more.

It is strange, but through art things are brought closer to us. In a way we begin to see things, because the artist has made these things visible for us. Seeing, as I understand it here, is closely tied with understanding, with grasping the meaning of things, with building up an emotional relationship. So it is very common to see in people's houses not pictures of things far away, but quite to the contrary, very near. In a Swiss chalet one sees pictures of chalets and mountains, maybe the mountain that one sees through the window. In Canada I saw in somebody's house a painting of

a waterfall twenty miles away. In a riding school one sees pictures of horses, in a Dutch farm of the cows, and a lover of cars will have pictures of them. Indeed, in this way these things gain in reality. Just as things to a certain extent don't exist if they are given no name, are not verbally formulated, so things that are never depicted remain dim and vague, as we have not learned to see them.

In all this the world is opened up for us, and is given form. We know things in the way the artists have formulated them for us. Art helps us to give form to facets of our life and helps us to grasp reality. Sometimes in this way even our life-style is formed, or at least influenced. Everybody knows how the film has gone deeply into the ways people live and think, their heroes, their view of the world, their dreams, and so forth. On one level film has often played a role in the formation of a new fashion, and fashion is certainly more than just the choice of colours or the length of a skirt; it means the way we move, even feel. If we think about the new society dance that was introduced by Irene and Vernon Castle in the years between 1910 and 1920 in New York, with the early jazz music of Jim Europe, we see how that influenced a whole new way of life, a way of moving, of clothing. It meant the end of formality, and the beginning of informal easy-going behaviour.

Art can also give form to our discontent, to our uneasiness with certain phenomena. It can give form to protest. If done in the right way it should not be destructive or break down what is not right. In the terms of our time I should like to translate the biblical injunction of 'hungering and thirsting for righteousness' into 'protest in love'. Film, song, painting, cartoons, slogans, may be the tools to do this. Certainly literature and poetry play their part. In a way art plays a large role in the liturgy of life. I chose this term in analogy to liturgy as we have it in church, the set forms in which we have moulded our services. The liturgy of life is the way we do things. Art creates the right surroundings, designs the clothes, designs the cup given to the winner, or

the sculpture that is the token of praise, as in the Oscar. In many ways the arts help here. In a way the organization of a solemn meeting, such as the inauguration of a president, is in itself a work of art. It counts in the way a restaurant is designed, the art of interior design, so that even the way we eat is influenced. Certainly music plays a large role in human life. That is its significance, based on its inner meaning.

4:4 Norms for art

We must know our limits and choose our genre as well as our subject since the genre itself is part of the communication.

The great norm in all this is love of God and our neighbour. In the Middle Ages they spoke of the manifold meaning of a text or a work of art. Its meaning was literal (that which was told or depicted), but also allegorical (that which was referred to, through the images or figures in the story), moral (the implications of the norms accepted), and anagogical. By this they meant the impact that the work was making, the direction in which it was leading our thoughts and emotions, the way it was moving us; in the direction of God and the life within his covenant, or away from it. Exactly here lies the truth, or lie, in art. Does it do the truth? (*cf.* Jn. 3:20,21). If we love our neighbour we certainly should not look down on him. Any snobbishness or élite-attitude is out of place. A beautiful example is Dr Isaac Watts, the well-known writer of hymns or metrical psalms in the early 18th century. He deliberately made his songs plain, abstaining from the intricate and flowery language often used by poets who were usually writing for a restricted and learned audience, with all kinds of references to myth, stories and literary figures the less educated could hardly understand. There is a place for that kind of poetry, but not if one is making church songs, hymns. Watts said he wanted the more simple church member to be able to understand them. Yet, and that is the beauty of it, he made his poetry such

that it was very fine, and could stand the test. In fact, it has stood the test of centuries, and many of the hymns he wrote are still sung today. And many people know parts of his work, without even knowing the writer, or realizing that it was deliberately composed in order to be cherished by people.

If we say that love is, as in all other things, the supreme norm for art, it certainly affects the subjects we choose, the way we treat them, the forms we give them, the materials we handle, the techniques we employ. In Philippians 4:8 Paul formulated this for all of life, and also art. In the last chapter of my book on modern art I tried to work this out at more length. This norm is certainly not above or beyond art. It is in the very strokes we put on paper, the beat of the drum, the way we attack a note on the trumpet, the kind of paint we use. Is art doing the truth?

Art shows our mentality, the way we look at things, how we approach life and reality. If we are among artists there may be a discussion about the details, about the techniques, about the pros and cons of this or that kind of dealing with an artistic problem, about the way we handle things. Here we will leave that undiscussed. But we only want to point out that none of those things is neutral.

Certainly this applies to the way we deal with a subject. In the past this was called decorum. One had to choose one's forms, types, expression in regard to the subject, and the situation in which the arts were to play a role. If one sees a play by Shakespeare one knows after three minutes whether it will be a comedy or a tragedy. Just as when one searches for some music on the radio a few notes are enough to know what kind of music one is hearing.

In our times the feeling for decorum is often lost. A good example I think is *Godspell*. Here we see boundaries neglected, a mistake against the norm of decorum. To treat such a high theme as the Passion as if it were a musical, a genre by definition light and entertaining, is wrong on all sides. The form does not do justice to the subject, and the subject

is dealt with in an irreverent way. It is a painful experience to sit through it. It is comparable to the example given above of the average Christmas card depicting the story at Bethlehem. No wonder that Christianity loses its force. Are these examples not a proof of how much Christianity has lost already? But many more examples could be found. Just go to the modern art museum and see how trite things are treated sometimes as if they were important and great, an exaltation of the too commonplace. Of course it can be done tongue-in-cheek. But it does show the relativism of our age, in which anything goes.

Often I have noticed among many young artists this by-passing of considerations of appropriateness and decorum. I saw a painting that depicted the 'column of fire at Mount Sinai'. It was in the form and on the level of a poster. I saw a young artist painting 'Ecce Homo,' Christ among his enemies, but it was badly done, and therefore below the line. If one cannot paint a good head, how can one tackle a subject so difficult that many artists in the past avoided it, as it was so hard to do in a convincing and right way? We must know our limits and choose our genre as well as our subject since the genre itself is part of the communication.

4:5 Norm and taste

In music, and in art in general, the good artist knows what ought to be done at a certain place and time, what is appropriate. It is a matter of good taste.

'There is no discussion about taste', is an old saying. I do not deny that. One person prefers landscapes, another portraits, one likes choral music, another orchestral, and another again chamber music. There is no discussion whether opera is 'better' than symphonies, or blues than jazz. But even if our preferences cannot be discussed, our choices can, since quality and content are not just a matter of taste, but a matter of norms. If we talk about portraits,

48

some are more, some are less beautiful, of a higher or a lower artistic quality. But our standard is not only defined by artistic quality; on the contrary, the higher the quality, the more important it is to discuss the content, the meaning, the anagogical direction. Exactly in the same way, a book by a great and intelligent writer on theology is not acceptable just because it is well written or deeply thought out. Even if it is so 'good' it must be assessed with care and maybe refuted as heretical, anti-biblical or ill-directed.

There is nothing wrong, even if it shows some narrow-mindedness, if somebody says, 'I like symphonic music, and dislike rock.' That is a question of taste. And within these boundaries one may prefer Haydn to Mozart, Brahms to Schubert. But not every symphony is good because it is a symphony. And there is always the question of content and meaning; what does it stand for anagogically? And also the question of decorum can be relevant.

As an example, Mozart composed several pieces of music for the mass. The music is beautiful, and could be apt if we were listening to an opera. But I do not think that kind of music, its tone and expression, fit for a mass.

Now these examples are about old music. Whatever we think, it does not change history, even if we may argue about the influence of the content of that music on us today. It is never neutral. But if we talk about contemporary things, our assessment becomes more important. If a record is at the top of the charts (I refer to rock and pop), it means that many people listen to it. Then it becomes imperative to discuss the meaning and content and the influence it has on people; not in the direct sense of one word, or one line, nor only the words. The music in its total impact in the melody, the rhythm, the harmony, is expressive as such, that is, expresses a mentality, a way of life, a way of thinking and feeling, an approach to life and reality. This is important to discuss, as this music helps to form the life-styles of those who cherish it. And how do we react to it? Our opinions are not irrelevant. We, in our reaction, create ripples which

influence our time. The better the record, artistically speaking, the more important this discussion will be. And if we understand that the music we were thinking about is an expression of a mentality, there are two more remarks to be made. If that music's 'energy' is worldly, anti-nomian (lawless) expressing uncertainty and even despair, then what are we to do with it? Music we have around us forms part of our environment and our life-style, that is, ourselves.

The Lord said that not what goes into us makes us unclean, but what comes out of us (Mt. 15:11). The environment that we create is something that goes 'out of us'. But for that same reason we should not conclude that we can never listen to that music. It would mean that we were cutting ourselves off from our own times. That is impoverishing and would also mean that we would not understand our contemporaries, those we want to communicate with about our Lord and the word he has given us, and what he asks from human beings in obedience to his word.

Another question is whether we can adapt that which is created by the world (that is, by people that do not know or love the Lord), and use it ourselves. There is no easy answer to this question, since the norm is that music or art in general should be good on the two levels we explained, the level of quality, and the level of mentality expressed. Sometimes Christians make bad music, because they have no talents or do not try hard enough or because they show their sinful nature, and sometimes the 'world' produces good music, like the blues of Mississippi John Hurt. If it is good it can be followed; if not we had better leave it alone.

Finally we ask on which level, in which situation, such music can be appropriate. The marches of Sousa are very fine, but totally inadequate for use in the church service. And is the rock music of today adaptable to Christian expression? Is it enough just to add other words? Music is never just words. Its expression is total, even more in the melody, rhythm and harmony than in the words. This does not mean, of course, that anything goes in the texts. Not only

ought there to be a unity between words and music, the music has to 'carry' the text, underline it as it were, but the expression found in the music has to be in line with the text. However the text itself certainly has to stand up. I have heard so-called Christian rock, in which the words were quite heretical and unbiblical.

In all this, questions of decorum, life-style, understanding, emotion and taste come in. Taste in the sense of a fine feeling for the right note, the right rhythm, the right form at the right time, together with the choice of the right word; in short, the feeling for what can and what cannot be done at a certain place and time. Also, the impact it makes on others; where it leads them, how they will understand it. Communication is complex and on many levels.

Life and art are too complex to lay down legalistic rules. But that does not mean that there are no norms. Although one cannot define the wrong kind of seductiveness or the right kind of prettiness and attractiveness of a woman by the length of her skirt or the depth of the décolleté, nevertheless women know the exact boundaries, especially the seductive kind of women, as they just play over the borderlines. So in music, and in art in general, the good artist knows what ought to be done at a certain place and time, what is appropriate. It is a matter of good taste.

I will add one more point. If we talk about Christian music we do not necessarily mean music with words that give a direct biblical message or express the experience of the life of faith and obedience in the pious sense. Obedience itself is not confined to matters of faith and ethics only. The totality of life comes in. It is the mentality, the life-style, that is given artistic form and expression. Bach's *Matthew Passion* is Christian, but so are his *Brandenburg concertos.* Not only the words of the cantatas are Christian, but also the instrumental parts of them. Otherwise we make Christianity narrow and leave a great part of our life that ought to show the fruit of the Spirit outside the commitment to God, our Lord and Saviour. On the other hand, I know paintings that

iconographically represent a Christian theme, but their content and impact are negative, blasphemous, in short, a lie. But then the other work of the same artist may express a quite un-Christian mentality.

4:6 Problems of art and style

In a way, an artist does not have a style that can be changed for another, but he is a style. In the style he shows who he is.

Today there is a tendency, resulting from a two-centuries-old way of thinking about art as something high, autonomous, almost religious, to narrow down art to 'great art', the painting in the art gallery, the classical music of the great romantic composers, great literature. There is no denying that it is art nor that it is important. But it often means that the crafts, or that 'folk' music of one kind or another, are passed by, not considered worthy of our attention.

This can go deeply into the lives of people. One day I met a girl who told me that she had always dreamed of becoming an artist. She asked my advice. Now her drawings were not so good that I felt I could encourage her. But I knew that she was very good at designing clothes, at making fabrics. So my advice was not to go to the painting department of some art school. It would mean plodding on for many years; at the end maybe a little pat on the back, but a whole pile of unsold paintings in the attic. I told her to search for a good art school in the area of the crafts, textiles or fashion. She did, and when I met her later she was happy. She even felt that she was at a more challenging place, learning more, than at the 'higher' art school, where people were discussing all day and doing very little; learning very little, like little geniuses without a goal.

Therefore it is good to consider what art is, again focusing on painting and sculpture, knowing that in other fields comparable distinctions could be made.

In visual art one can look for two different qualities. One

is the amount of naturalness, of depicting force, of representational quality. Here one can range from zero, the totally non-figurative, the pure form, to the extreme of naturalism. At the one end one has the curve, the circle or the square, the pure colour or the simple pattern. At the other there is the precise rendering of visual impressions, as in a still life by Harnett, or the precision of Jan van Eyck, rendering things in full detail.

The second approach speaks more about the function in regard to the load of meaning that the work carries. Here at the lowest level (low does not mean less), one discerns ornaments, beautifying forms, colours, valuable in themselves. Certainly this often has great significance. At the highest, the icon, the loaded work that encompasses so much meaning as it carries so many values, stands for such great realities. The idol is a specific, and in a deep sense sinful, example of an icon. It is the god then. But we think also of Michelangelo's *David*, as it were the personification of all that the Renaissance of Florence stands for; the greatness of man. Or think of Rembrandt's *Jewish Bride*, that stands for not just Rembrandt or 17th century Holland, but also for the greatness of human married love. Of course one can think also of the Byzantine icons. Between these two extremes all works of art have a place, sometimes more loaded, sometimes less.

Every work of art is characterized by these two elements. It can be decorative, low in iconic meaning, even if it shows precisely painted flowers, as with 19th century wallpaper. It can be iconically important even if its representational value is low, as with Paul Klee or abstract expressionistic work.

The point now is that all these different kinds of art, with or without high icon value, with or without precise representational quality, are valid. It just depends on the function it has to fulfil. Again, decorum is the norm here. But if a decorative work is well done it may have less icon-value, but that does not mean less artistic value or less significance, and certainly it does not mean that the man who made it is a

lesser artist.

Really great art often 'works' on several levels at the same time. Consider a baroque church in Southern Germany, Ottobeuren is a fine example. Here the arts 'work' decoratively. They are just there to adorn the church. But if one looks more closely, one sees figures, fine floral ornamentation, and when one takes more time, one sees the stories, and, beginning to understand these, one sees their meaningful content, in relation to the totality of the church and its function, and so on to a grasp of the underlying programme. Here as it were all levels of iconicity and of representational value are present. It is at the same time decorative and loaded with meaning, working as colour scheme and ornamental finery and representational precision. If we understand these things, we can also grasp that the discussion between figurative and non-figurative in the visual arts is of no great importance. I avoid the term abstract on purpose. There has always been non-figurative art, mainly in ornaments and such. And great paintings have always 'worked' also on that level, apart from the figuration they give and the meaningful story depicted. And figurativeness does not always mean great depth and loaded meaning. The question is not whether non-figurative art is right or not, but two other questions need to be taken into account if we want to discuss at a meaningful level. The first is the question of decorum, the function of the work of art, in its own setting. So an ornament, or the pattern of a fabric can be non-figurative. But so can a large sculpture, if it stands on a place where it is appropriate. In a way, the Eiffel tower was such a non-figurative sculpture, the landmark of an exhibition in 1889. Or, on quite another level, consider the shape of our watch or car. We usually call that industrial design. Even here, in these forms, there is inherent meaning. A car-form can stand for luxury, for speed, or for efficiency. To decorate the hall of a hotel, one can choose some figurative, decorative panel, but also it may be appropriate to choose some pattern with large coloured areas. Taste is here a guiding principle, feeling

for what is appropriate.

To me what is never good is the abstract, which means the denial or the dismissal of reality, the negative attitude to reality. By negative I do not mean showing the wrong as wrong, bringing into art a sense of the curse, of sin, of the unacceptable as such. I am not asking for only sweet idealistic pictures. They can be lies just the same, by-passing the realities of life, as some 'Christmas' pictures do. But by a negative attitude I mean that reality as such is considered negative. We often find this in modern art, but that is not under discussion here.

So what is to be taken into account is the place, the decorum, and what has to be discussed is the meaning in telation to that role. Again, art is never neutral, and always rhe totality of our humanness is involved if we want to discuss it adequately.

And now some words about style. Often I have been asked by a young artist which style to choose. To me this is an embarrassing question. One cannot choose a style at random, as style is part of the content, as the expression of the art-work is in the artistic form itself. In a way, an artist does not have a style that can be changed for another, but he *is* a style. In the style he shows who he is. This does not mean that within the larger framework of a style there will not be differences of style in relation to the function and place of the specific work, light at a wedding party, deep and solemn at a social occasion of great weight, tragic and dirge-like at a funeral. But style cannot be chosen at random. Certainly we should not 'choose' a style just because we want to be 'in', 'with it', make our work better saleable or popular. We should have the courage to be ourselves, to be honest. This to me is the minimum requirement for any work of art. We should never compromise our principles or deep aims. Also, we should not just follow trends and fashions as they come and go. That could be in a bad sense 'worldly', and show that we have not much to offer of our own. It can easily be understood that a young artist is seeking for style, that he is

experimenting with the possibilities of expression. But once a style is found, that is 'him'. Of course that does not mean that it is unchangeable. It will grow with the artist, in depth and width. In one word, it will become more mature. Usually that also means greater simplicity and directness, just because the complexities are mastered, and much is brought into a few images. This is the master's work.

Both elements can be seen in the history of art. In the work of one artist one sees a development, a process of maturation, of gradual changes as life goes on. Sometimes one sees rather sudden changes in style, in the forms of expression. That always means that a drastic change in the direction of the artist's life has taken place, either a conversion to another spiritual principle, or the influence and impact of a person or a movement.

4:7 Fame and anonymity

We have only added to the world God gave us to develop, to beautify. We have added to the lives of many, loving our neighbours. That should be the greatest achievement.

Some artists have become famous. Some of their names are known to everybody. It does not necessarily mean that their works are really known to everybody. But there are thousands and thousands of artists who are not known. If we look into the large artist-biographical lexicons we see many names. They are at least known to the specialist. But apart from these, there are many whom nobody has ever heard of. Yet there was someone who made that particular statue that is the delight of everybody who travels to a certain place with an open eye. Maybe it is well cherished by the 'local people'. When these people say they love their town, that particular statue is part of the image of the place, and it certainly would mean that if it were lost many people would miss it. His statue is famous, but who knows him? Ask people who made the statue that is the landmark of

Copenhagen, or who made the monument in Trafalgar Square, and the lions that everybody has seen there. What I want to say is that much of the artist's work is anonymous. In that sense he shares the fate of the many who work for the public benefit. Who made the train you ride in? Who is the clever man who made the schedules for BBC radio? Who designed that handy thing you use every day?

Maybe the anonymity is not a fate, or a tragedy, but quite normal. The praise for that monument, that handy thing, is the highest reward one can get. A good poster; who knows who made it? Who cares? Maybe he is known to his colleagues. The specialists will know. But in due time he is forgotten. Who knows who made this or that beautiful statue in Babylon, in Egypt, in Greece or Rome? Who made the famous Marcus Aurelius statue on Capitol Hill in Rome? Or who erected the obelisk on the Mall in Washington D.C.?

All this I feel to be right. The fame goes with the work, if it is done well. Panofsky, in his book on Suger, speaks about this in a very wise way. He compares Suger with Michelangelo. Do you know who Suger was? Suger was a great bishop in France in the 12th century. In many ways he was responsible for the gothic style. He was the builder of St Denis, the man who chose and guided the artists. He was a very important man in his time, though only specialists have heard of him. Yet everybody who admires the gothic style, is praising Suger's vision and great abilities.

Suger, says Panofsky, did search for fame, but it was centrifugal. The fame was in the things he did. That of Michelangelo was centripetal. That means it always ends in Michelangelo himself. You go and look at the *Pieta*. What do you search for? A beautiful Madonna? A moving dead body of Christ? Or do you see Michelangelo? The same is true of his other works. In a way we forget the thing we are looking at, and we leave the monument not saying, 'how terrible and yet how joyful was the Last Judgment,' but, 'Michelangelo did it, and how great he was!'

Which of these two do you look for? We may criticize Suger for some of his ideals. If we say that the Roman Catholic churches are over-adorned, that the art is too much, some of that means criticizing Suger's vision. Yet I think his ideal of fame is more Christian than Michelangelo's. Or, if not Michelangelo's, than the people who gave him this praise.

In short, we should not look for fame. It may be kindling the sin of pride. It may mean we lose our humility. And God may miss the praise he is owed. This, I think, is the lesson we learn too in Ecclesiastes. All things are vanity, and even the highest praise is evaporated in the air after a while, a year, a century, or maybe hundreds of years. Yet the meaning of work done well is in the joy to have been able to make something that was of some use to somebody, and in that way adding positively to the flow of history in the direction of the kingdom of God.

Maybe young people dream of becoming famous. But it can be dangerous, leading to compromises, to dishonesty even, just to achieve easy fame.

It is better to dream of developing one's talents, to achieve the best one can. Let others decide and judge and give praise. Do not let that fool you. In the end one has to stand before the Supreme Judge, the great Lord Almighty. Probably one will say then, 'Lord, I have only been an unworthy servant of yours, but I have tried to use my talents. It was not perfect, but you gave me so much that I have to thank you for whatever the world says I did.'

In the last resort art is anonymous. Who knows the names of the great sculptors of the gothic cathedrals? Who knows the names of the architects of even the building that has been made quite recently? Everybody knows that a good performance is never the work of one person alone, but that he needed the help of many others. He was in a way the brand name, the trade mark. The paintings, the songs, the good designs of cars and other industrial products are anonymous. It is good that way. We have only added to the world

58

God gave us to develop, to beautify. We have added to the lives of many, loving our neighbours. That should be the greatest achievement.

4:8 The qualities of the artist

Four qualities determine the scope and depth and importance of the artist, any artist. They are talent, intelligence, character and application.

Talent: the term is taken from the Bible, the story that Jesus told of the talents. Indeed, a talent is given. It is a potential which one has to use with responsibility. Our Lord has the right to ask, and certainly will ask what we did with it. Something to give thanks for? Certainly; without this no artist can be of any importance. Yet it is nothing exclusive to the artist. Other people have talents. Everybody has been given qualities, positive ones to use and to develop, and there are also negative ones, our weaknesses which we have to fight.

By *intelligence* we mean the quality to analyse a situation, to find the right form, to give the right solution to the artist's problem, to master the complexities of the art, to express clearly what one wants to achieve. In a way this is also a given quality. Some people may describe it as a talent. Again there is the necessity to develop this.

Character is a very important quality of the artist. It often determines his greatness and importance. Many artists have failed here. One, early in his life, has success with some work and then he goes on doing that same thing. What was a creative act, the development of a new principle, becomes in this way a trick, an easy achievement. He dries up, and ends quite second-rate. There have been great artists who have ended this way. Another temptation for an artist is to use his talent below his level in order to make money, to be popular and acceptable. Here, to choose an example out of the history of jazz, it would be very fruitful to compare

59

Jelly Roll Morton and Louis Armstrong. Of course, as jazz had been such a great influence on popular American music, the temptation to become 'commercial' and to 'go pop' is very great. Louis Armstrong fell for this. Somewhere around 1930 he went commercial, and his work became easy and popular and full of tricks and effects. At times he tried again to do something good and creative, but he almost always failed. He even ended sometimes on the level of a clown, singing lullabies for children on TV, in bad taste. Yet he was a great musician, a great trumpeter. But to hear it, one has to listen to his work with the Hot Five or Hot Seven in the years 1926–27, or to his early work with the great King Oliver Creole Jazz Band of around 1922–23. Happily we still have the recordings. We can understand it though. The years after the crisis of 1929 made it very hard for a musician to make a living, and as good quality music was not appreciated enough by the public, who preferred it sentimental and 'light', the temptation was great to cater for these bad tastes As always, apart from personal weakness and sin, there is also the communal guilt, the situation our society, our environment, puts us in. Jelly Roll Morton, the great jazz pianist however, refused to sell out his art to cheapness. He fought on for quality and the principles he stood for. As a result he is still a great artist who has a chapter in any worthwhile history of jazz. But his name is forgotten by the public for whom he refused to play the clown or the caterer of sounds. And he suffered many years of poverty and neglect, just as so many other great jazzmen suffered and sometimes even died in the thirties.

In the lines above one should not read that entertainment as such is wrong. In a way all art is entertainment, the God-given opportunity to relax with good music, with good art, a fine book. And there is nothing wrong with a ballad, with dance music (Mozart made quite a bit of it), or with making cartoons, posters, illustrations. But whatever one does, it has to have quality. Remember what we said before of Dr Isaac Watts. He wrote popular songs on the highest level.

Or think of Toulouse Lautrec, whose posters are still hanging on people's walls, even if the performances he was advertising took place so long ago, and the performers have all passed away. Most people even do not know the kind of songs they were singing. If the work is done well, it survives the occasion, like the Mozart music we still listen to. We still play Bob Dylan, even if the period of protest in which his music played such an important role has gone by. One can still look with pleasure at the good entertainment film of years gone by, even if the style is dated.

Of course it is dated. Whatever we do, we can never escape being of our time. We live in the now, inevitably. But a thing of beauty survives, if its qualities are not ephemeral.

The last quality of every good artist is application. The old saying is that any good work of art is 95% perspiration, and 5% inspiration. Some people may want to place hard work under the heading of character. Anyhow, no great work of art comes by itself, as product of chance. There is no instant art. Apart from coffee nothing is instant in this world! I remember the words of a great pianist. He said, 'If I do not do my exercises one day, I will hear it the next day. If I do not do them for two days, my wife hears it. If not for three days, my best friends will notice. After four days, the public will notice.'

Then there is that charming story of Hokusai, the great Japanese painter and maker of woodcuts around 1800. Once somebody asked him for a painting of a rooster. He said, 'OK, come back in a week.' When the man came, he asked for postponement; two weeks more. Then again, two months, then half a year. Then after three years the man was so angry, that he refused to wait any longer. Then Hokusai said that he would have it there and then. He took his brush and his paper and drew a beautiful rooster in a short time. Then the man was really furious. Why do you keep me waiting for years if you can do it in such a short time? 'You don't understand', said Hokusai, 'come with me'. And he took the man to his studio, and showed him that all the walls were

covered with drawings of roosters he had been doing over the last three years. Out of that came the mastery.

This story of course does not mean that we can keep people waiting, and that we should not fulfil our promises. The lesson is that even improvisation and so-called spontaneous achievements can only be the result of hard work. No artist can ever reach the top if he does not start his day with rehearsing, a painter drawing for a few hours, a musician practising, anybody studying. Genius is not enough.

4:9 On the way

. . . an exciting road, full of new vistas, a walk in the direction of the Promised Land, while even now we experience much of what is waiting for us to come.

Of course we pray and ask for God's help. Of course the Holy Spirit is behind us. But God, in his great mercy and wisdom, takes man seriously; as his creature, even in his own image. We never become passive instruments of God's Spirit. He gave us a personality, gave us freedom and responsibility, so we never can say that our work is directly inspired and therefore his. It would be blasphemous to say that our work is God's work. But we may praise him for the life-renewing force he gave us in Christ, and for his help if we achieve something that is full of love, life, beauty, righteousness, peace and joy, maybe after long searches and studies.

It comes down to this; a Christian artist is an artist who works, thinks and acts as an artist, using his talents and possibilities, but one who works maybe with another mentality, and with another priority in his life. This mentality implies certainly that we work in freedom. We do not need to prove ourselves; since the search for fame and our pride do not need to hinder us, and we do not need to make our own eternity.

Maybe the best way to express this is to say that we are on the way. The Bible often uses this metaphor. The Scripture

is a lamp for our feet on the path that we follow through this dark world. Go on the narrow path. It may be difficult, and asks for an effort. But going on the 'wide road of sin', letting yourself go, doing whatever you want, leads to the destruction of yourself, already in the here and now. Follow me! Those are Christ's words. Know where you are going. Christ even applies this way of speaking to himself when he says that he is the way. To live is to go, on a way, with him; a way of life, in a deep and very real sense, a way of truth, as he is the Truth, and we ought to *do* the truth, which is to love God and love our neighbours. The way is a way of freedom, love and humility, but it is God's way of holiness, where he helps and leads. The way is sometimes hard to follow and sometimes asks for sacrifices, in extreme cases even for our mortal bodies in martyrdom, but it is also an exciting road, full of new vistas, a walk in the direction of the Promised Land, while even now we experience much of what is waiting for us to come.

CPSIA information can be obtained at www.ICGtesting.com
Printed in the USA
BVOW08s0049020515

398224BV00001B/19/P

9 781573 834414